₩₩₩₩₩₩₩₩₩₩ </2 W9-BBO-080

BOOKS IN THIS SERIES

- Draw 50 Airplanes, Aircraft, and Spacecraft
- Draw 50 Aliens
- Draw 50 Animal 'Toons
- Draw 50 Animals
- Draw 50 Athletes
- Draw 50 Baby Animals
- Draw 50 Beasties
- Draw 50 Birds
- Draw 50 Boats, Ships, Trucks, and Trains
- Draw 50 Buildings and Other Structures
- Draw 50 Cars, Trucks, and Motorcycles
- Draw 50 Cats
- Draw 50 Creepy Crawlies
- Draw 50 Dinosaurs and Other Prehistoric Animals
- Draw 50 Dogs
- Draw 50 Endangered Animals
- Draw 50 Famous Cartoons
- Draw 50 Flowers, Trees, and Other Plants
- Draw 50 Horses
- Draw 50 Magical Creatures
- Draw 50 Monsters
- Draw 50 People
- Draw 50 Princesses
- Draw 50 Sharks, Whales, and Other Sea Creatures
- Draw 50 Vehicles
- Draw the Draw 50 Way

Cars, Trucks, and Motorcycles

THE STEP-BY-STEP WAY TO DRAW Dragsters, Vintage Cars, Dune Buggies, Mini Choppers, and Many More...

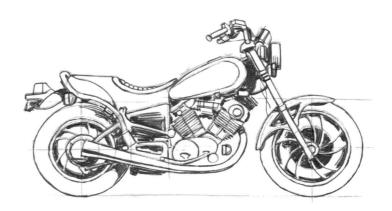

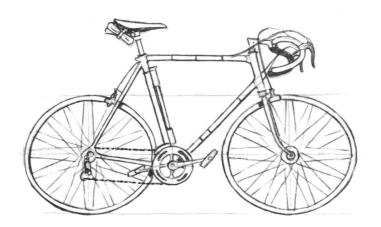

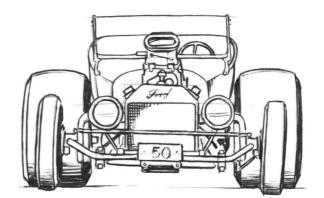

Cars, Trucks, and Motorcycles

THE STEP-BY-STEP WAY TO DRAW Dragsters, Vintage Cars, Dune Buggies, Mini Choppers, and Many More...

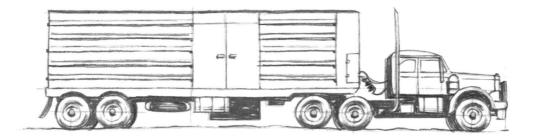

LEE J. AMES

WATSON-GUPTILL PUBLICATIONS Berkeley Copyright © 1986 by Jocelyn S. Ames and Murray D. Zak

All rights reserved.

Published in the United States by Watson-Guptill Publications, an imprint of the Crown Publishing Group, a division of Random House LLC, a Penguin Random House Company, New York. www.crownpublishing.com www.watsonguptill.com

WATSON-GUPTILL and the WG and Horse designs are registered trademarks of Random House LLC.

Originally published in hardcover in the United States by Doubleday, a division of Random House LLC, New York, in 1986.

Library of Congress Cataloging-in-Publication Data

Ames, Lee J.

Draw 50 cars, trucks, and motorcycles.

p. cm.

Summary: Provides step-by-step instructions on how to draw a variety of cars, trucks, and motorcycles, including a Ford Thunderbird, cement trucks, and minibikes.

 Motor vehicles in art-Juvenile literature. 2. Drawing-Technique-Juvenile literature. [1. Motor vehicles in art.
Drawing-Technique] I. Title. II. Title: Draw fifty cars.

NC825.M64A44 1986 743'.896292 85-13157

ISBN 978-0-8230-8576-7 eISBN 978-0-770-43287-4

Printed in the United States of America

10 9

2014 Watson-Guptill Edition

To Mark David and Hillary Leigh, my two grand kids!

. . . and thanks to Warren Budd for all his help.

TO THE READER

This book will show you a way to draw cars, trucks, bikes and motorcycles. You need not start with the first illustration. Choose whichever you wish. When you have decided, follow the step-by-step method shown. *Very lightly* and *carefully*, sketch out step number one. However, this step, which is the easiest, should be done *most carefully*. Step number two is added right to step number one, also lightly and also very carefully. Step number three is sketched right on top of numbers one and two. Continue this way to the last step.

It may seem strange to ask you to be extra careful when you are drawing what seem to be the easiest first steps, but this is most important because a careless mistake at the beginning may spoil the whole picture at the end. As you sketch out each step, watch the spaces between the lines, as well as the lines, and see that they are the same. After each step, you may want to lighten your work by pressing it with a kneaded eraser (available at art supply stores).

When you have finished, you may want to redo the final step in India ink with a fine brush or pen. When the ink is dry, use the kneaded eraser to clean off the pencil lines. The eraser will not affect the India ink.

Here are some suggestions: In the first few steps, even when all seems quite correct, you might do well to hold your work up to a mirror. Sometimes the mirror shows that you've twisted the drawing off to one side without being aware of it. At first you may find it difficult to draw the boxes, triangles, or circles, or just to make the pencil go where you wish. Don't be discouraged. The more you practice, the more control you will develop. Use a compass or a ruler if you wish; professional artists do! The only equipment you'll need will be a medium or soft pencil, paper, the kneaded eraser and, if you wish, a compass, ruler, pen, or brush.

The first steps in this book are shown darker than necessary

so that they can be clearly seen. (Keep your own work very light.)

Remember, there are many other ways and methods to make drawings. This book shows just one method. Why don't you seek out other ways and methods to make drawings from teachers, from libraries and, most importantly . . . from inside yourself?

LEE J. AMES

SPECIAL NOTES:

On drawing wheels:

Since many of the wheels in this book are angled and not perfect circles, I've used a "drawn from quartering" method to achieve the appropriate roundness.

"Faking":

When drawing complex motor or machinery detail, if you were to include every nut, bolt, spring, cylinder etc., it would take forever and distract you from being concerned with the whole picture. "Faking" is one solution. "Faking" is drawing in the general look of something as complex as an engine with strong strokes, dashes, dots, squiggles etc. that just suggest the subject. See below:

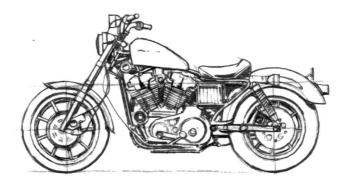

TO THE PARENT OR TEACHER

"Leslie can draw a Rolls-Royce better than anybody else!" Such peer acclaim and encouragement generate incentive. Contemporary methods of art instruction (freedom of expression, experimentation, self-evaluation of competence and growth) provide a vigorous, fresh-air approach for which we must all be grateful.

New ideas need not, however, totally exclude the old. One such is the "follow me, step-by-step" approach. In my young learning days this method was so common, and frequently so exclusive, that the student became nothing more than a pantographic extension of the teacher. In those days it was excessively overworked.

This does not mean that the young hand is never to be guided. Rather, specific guiding is fundamental. Step-by-step guiding that produces satisfactory results is valuable even when the means of accomplishment are not fully understood by the student.

The novice with a musical instrument is frequently taught to play simple melodies as quickly as possible, well before he learns the most elemental scratchings at the surface of music theory. The resultant self-satisfaction, pride in accomplishment, can be a significant means of providing motivation. And all from mimicking an instructor's "Do-as-I-do . . ."

Mimicry is prerequisite for developing creativity. We learn the use of our tools by mimicry. Then we can use those tools for creativity. To this end I would offer the budding artist the opportunity to memorize or mimic (rote-like, if you wish) the making of "pictures." "Pictures" he has been anxious to be able to draw.

The use of this book should be available to anyone who *wants* to try another way of flapping his wings. Perhaps he or she will then get off the ground when a friend says, "Leslie can draw a Rolls-Royce better than anybody else!"

LEE J. AMES

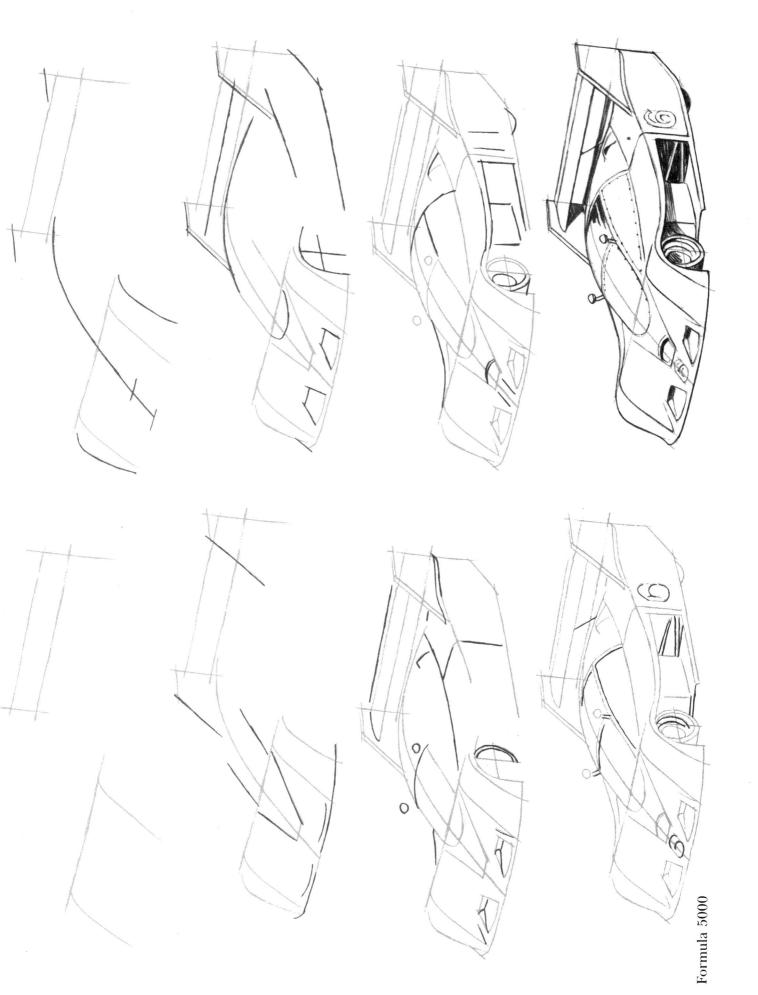

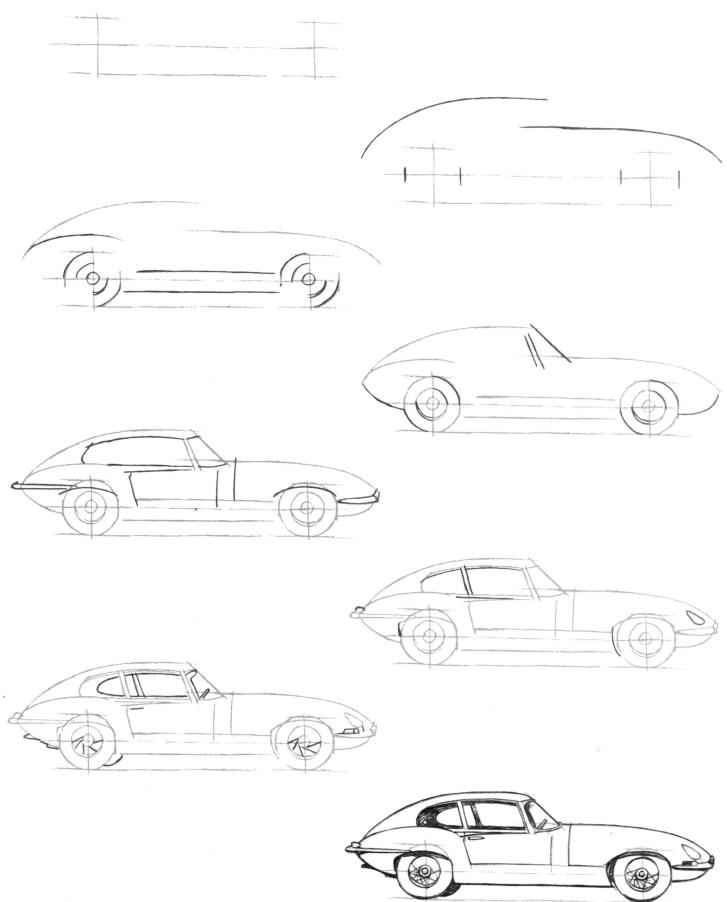

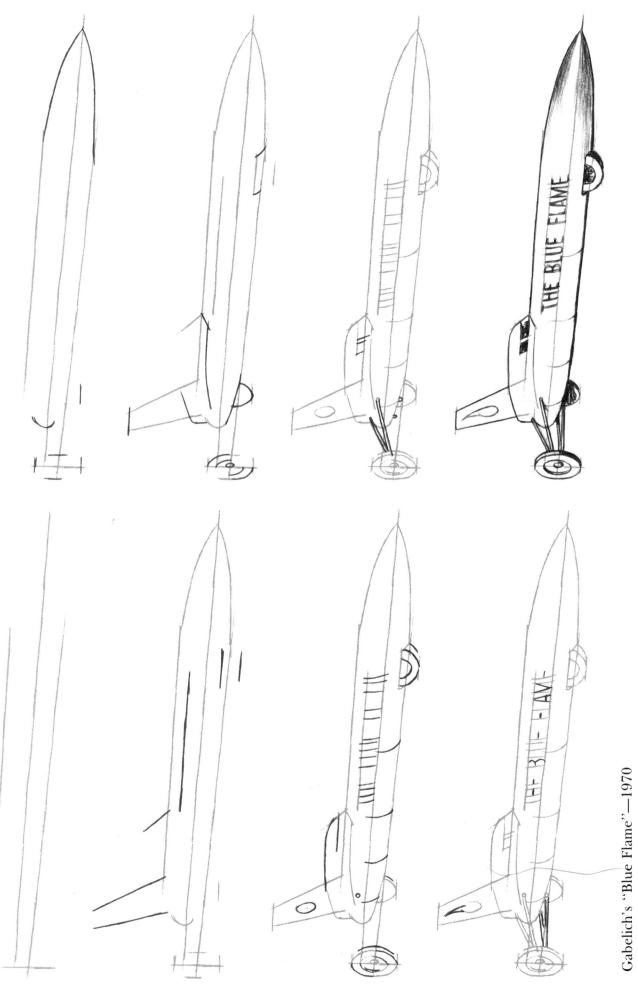

1984 Chevrolet Corvette

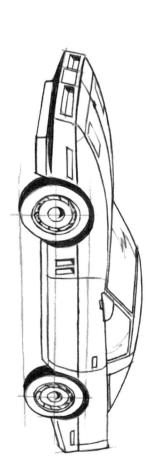

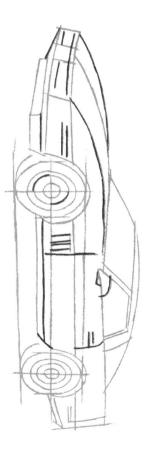

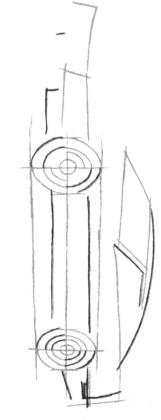

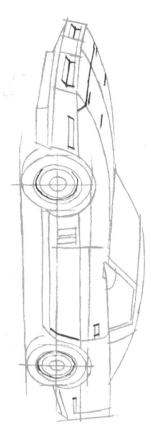

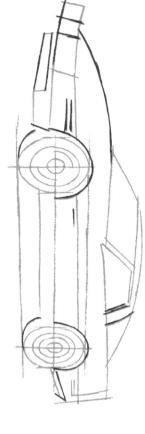

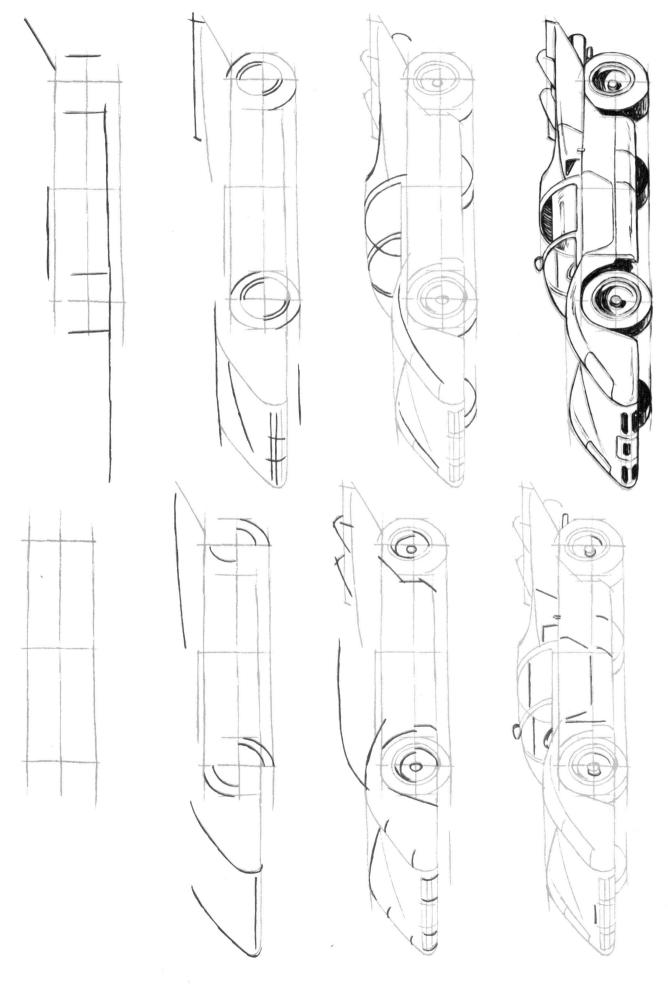

Ferrari 512S Racer

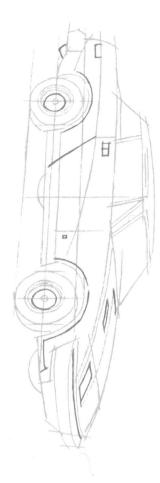

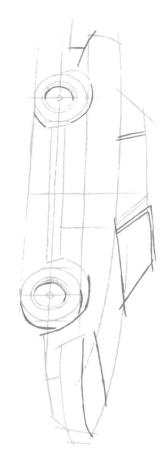

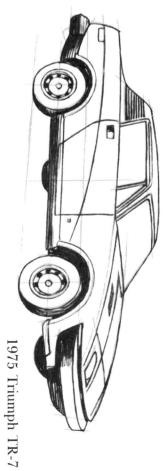

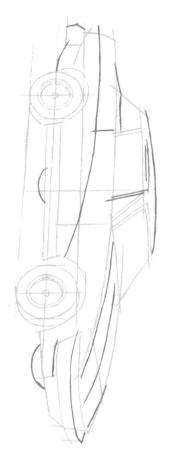

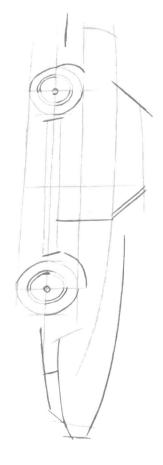

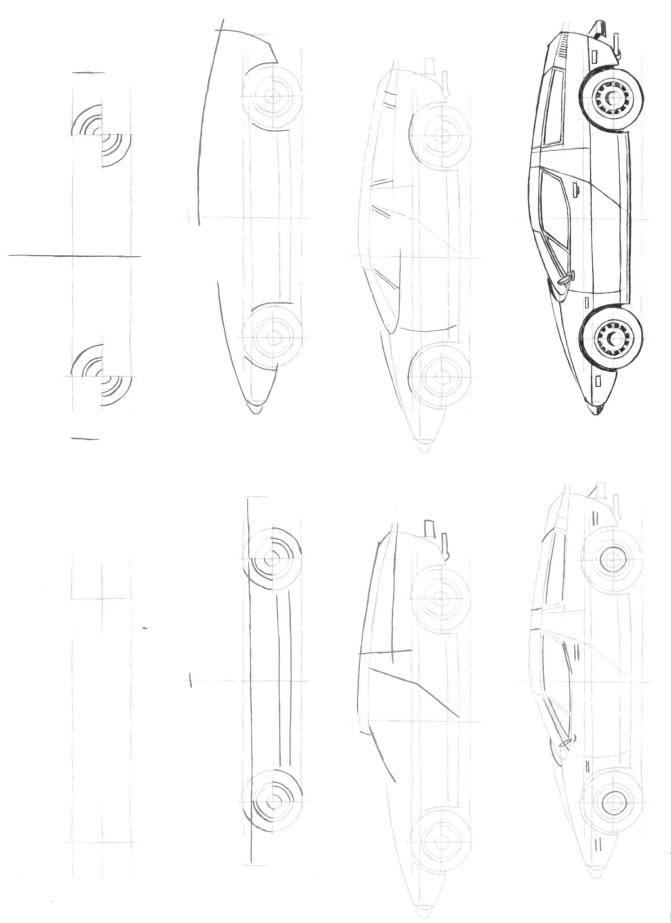

1977 Maserati Bora

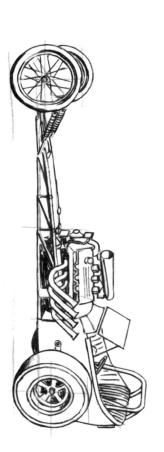

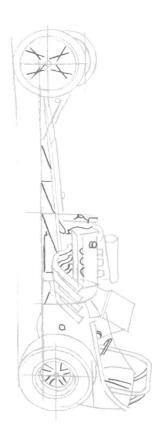

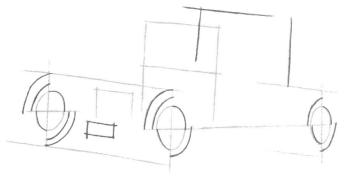

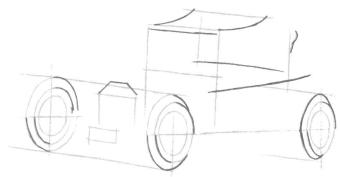

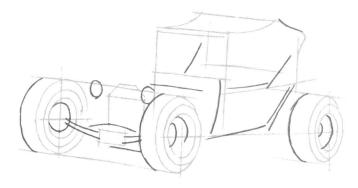

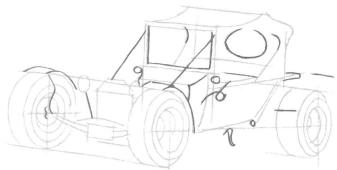

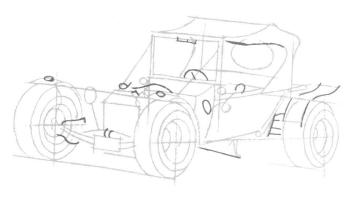

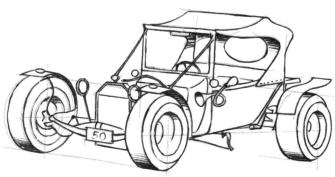

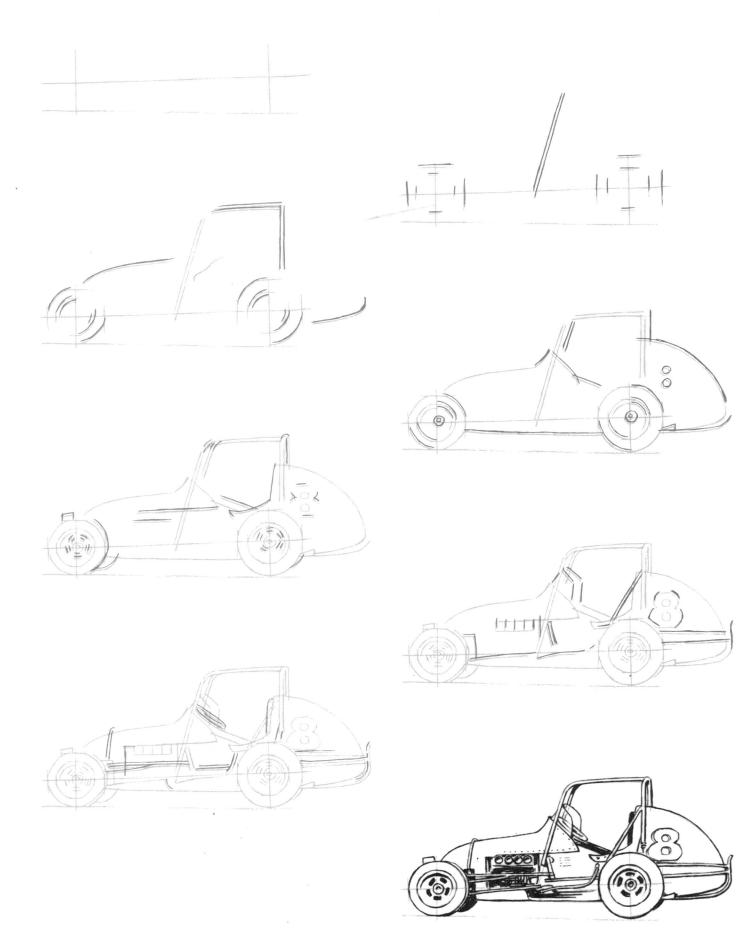

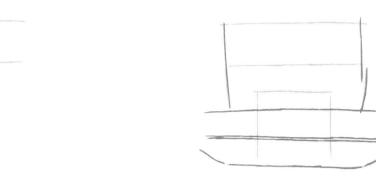

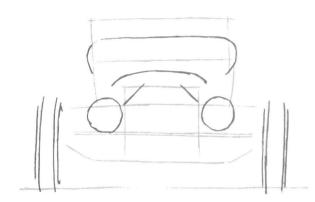

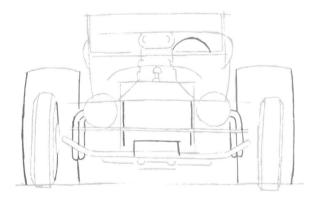

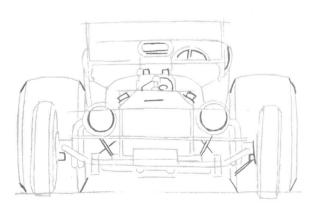

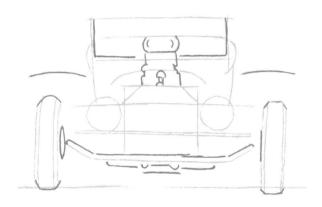

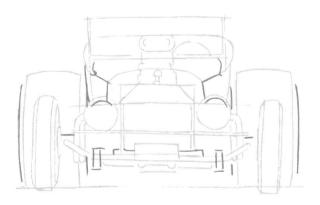

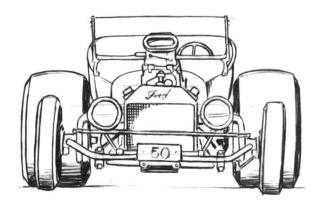

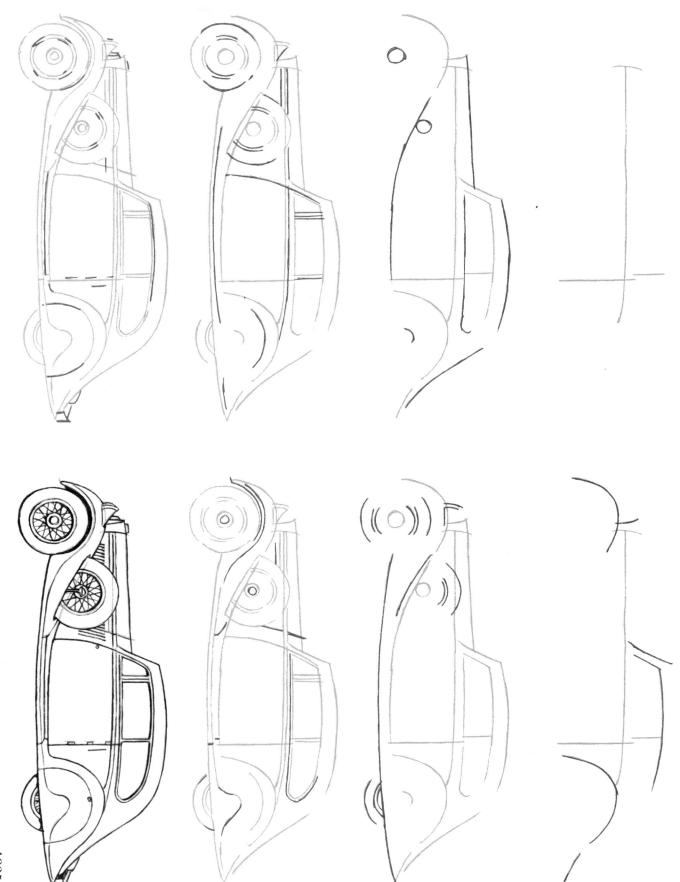

1935 Bentley

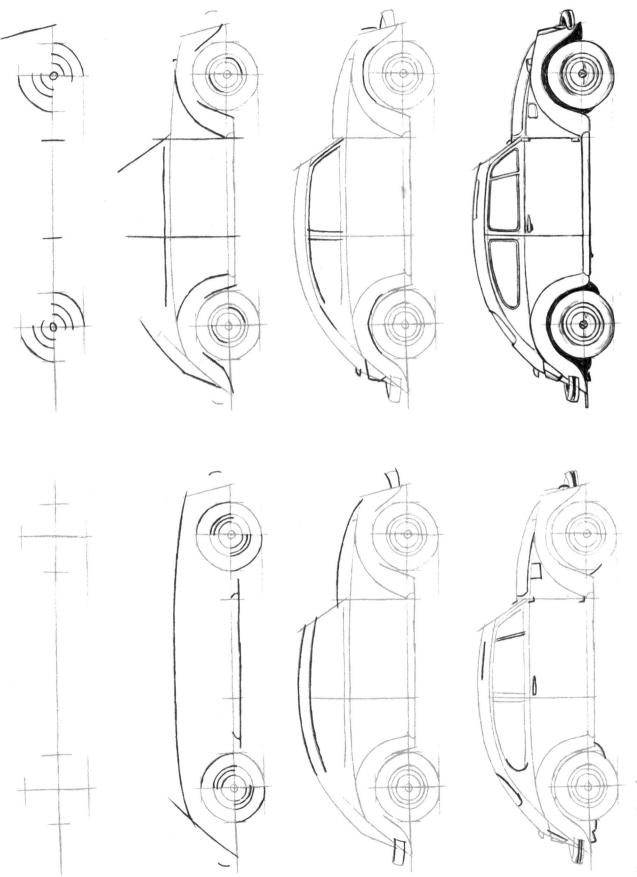

1974 Volkswagen Beetle

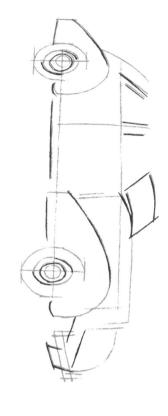

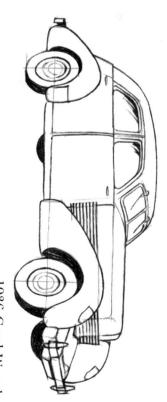

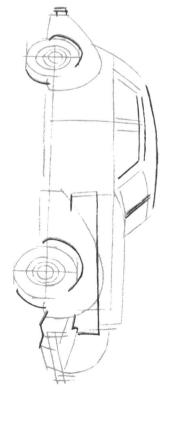

1936 Cord Westchester

0

1936 Bugatti Surbaisse

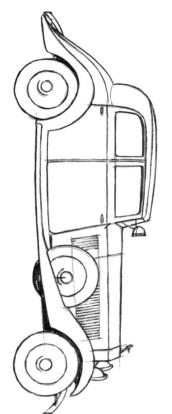

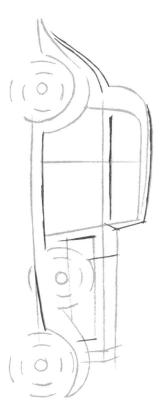

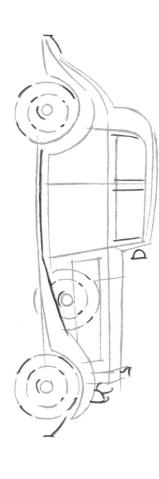

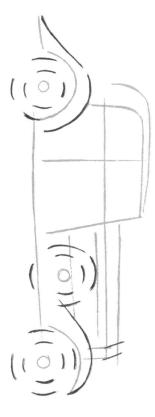

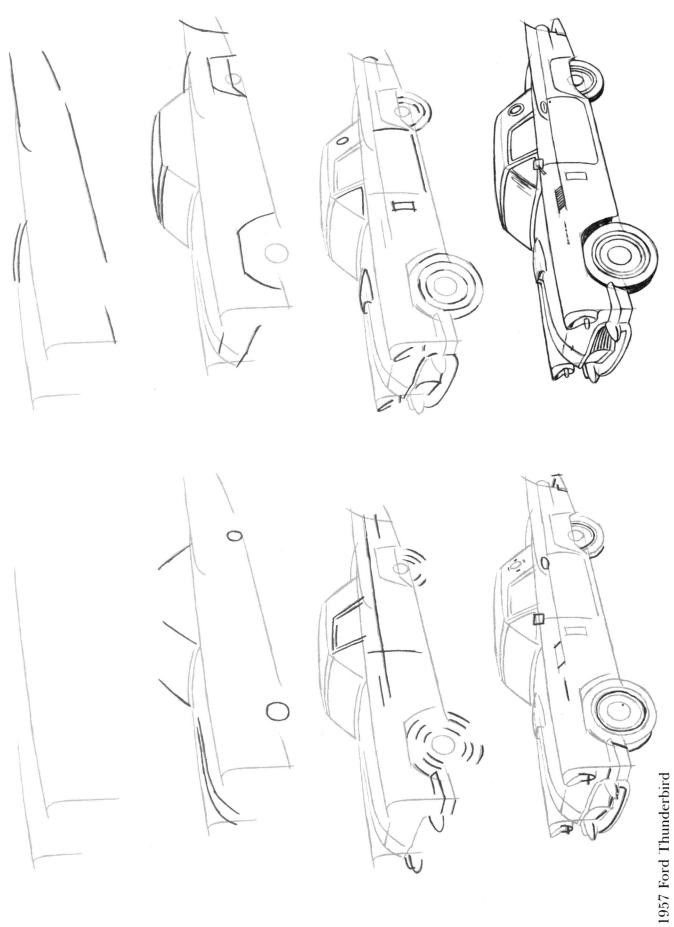

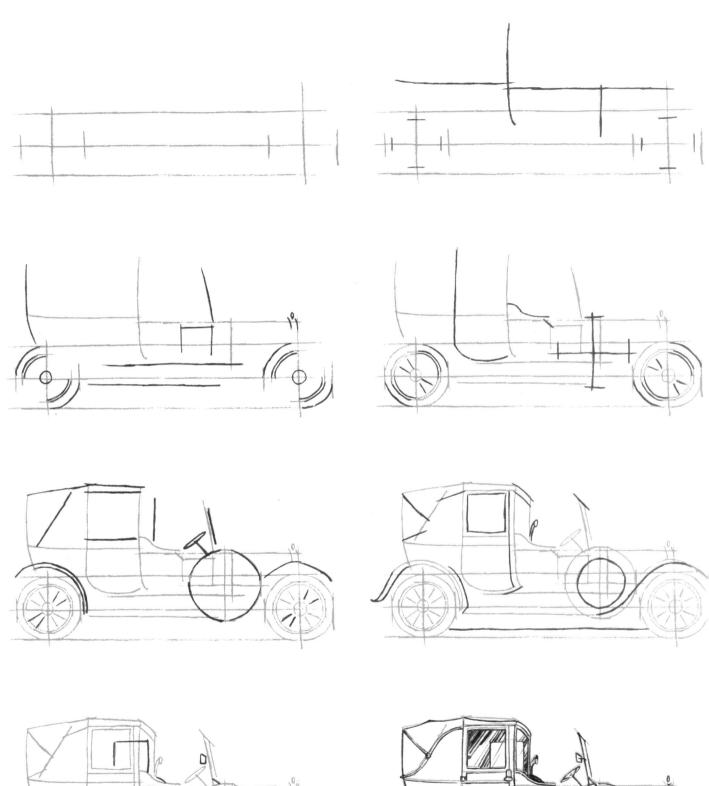

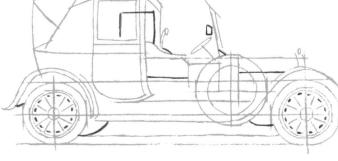

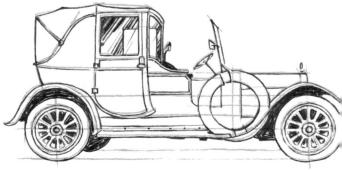

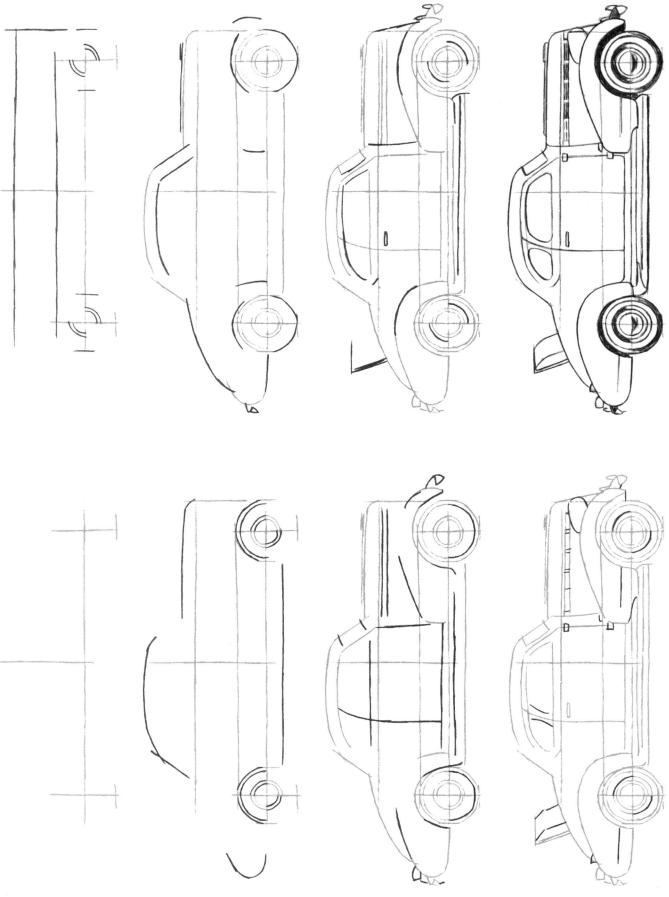

1937 Pontiac Rumble-seat Coupé

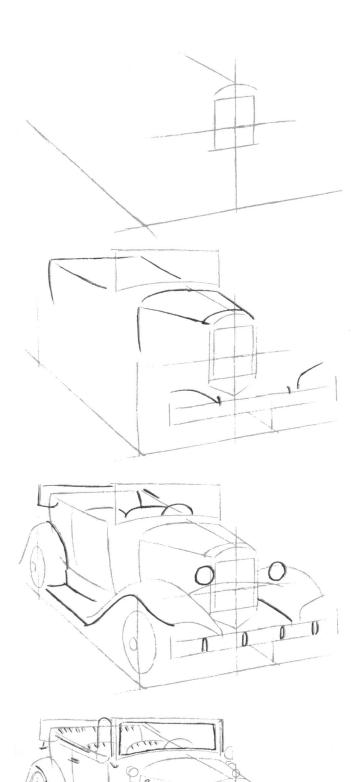

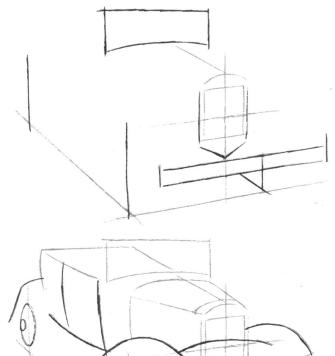

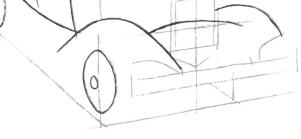

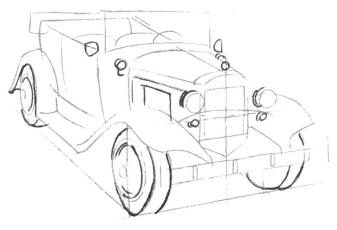

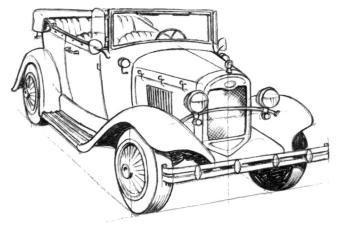

1974 Glassic Model A replica

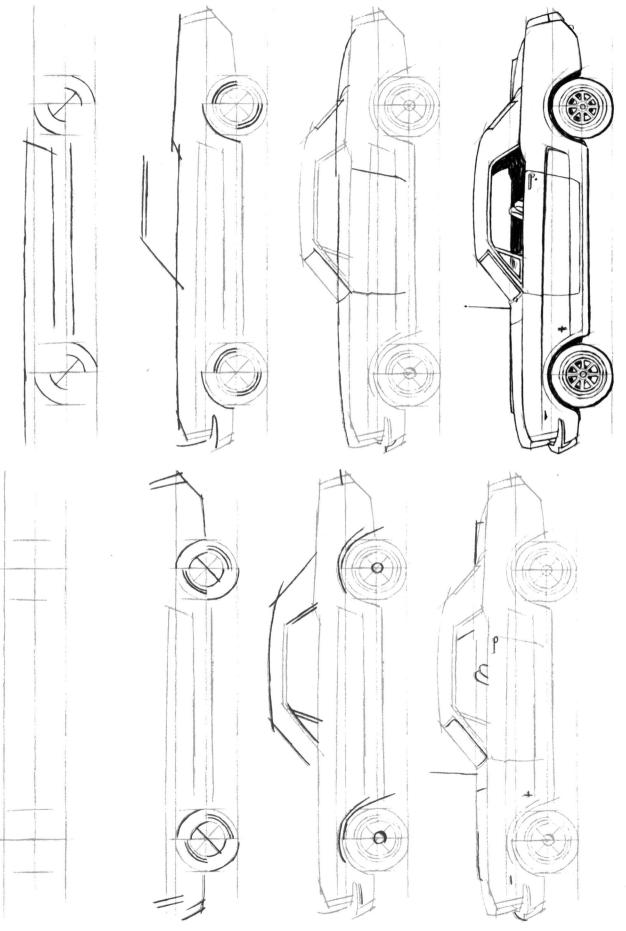

1964 Ford Mustang

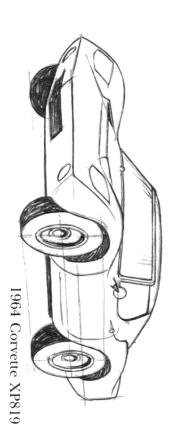

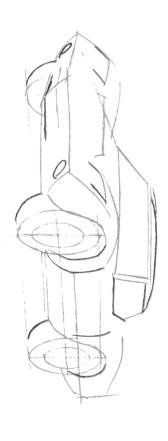

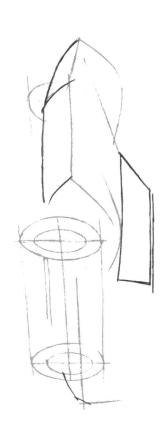

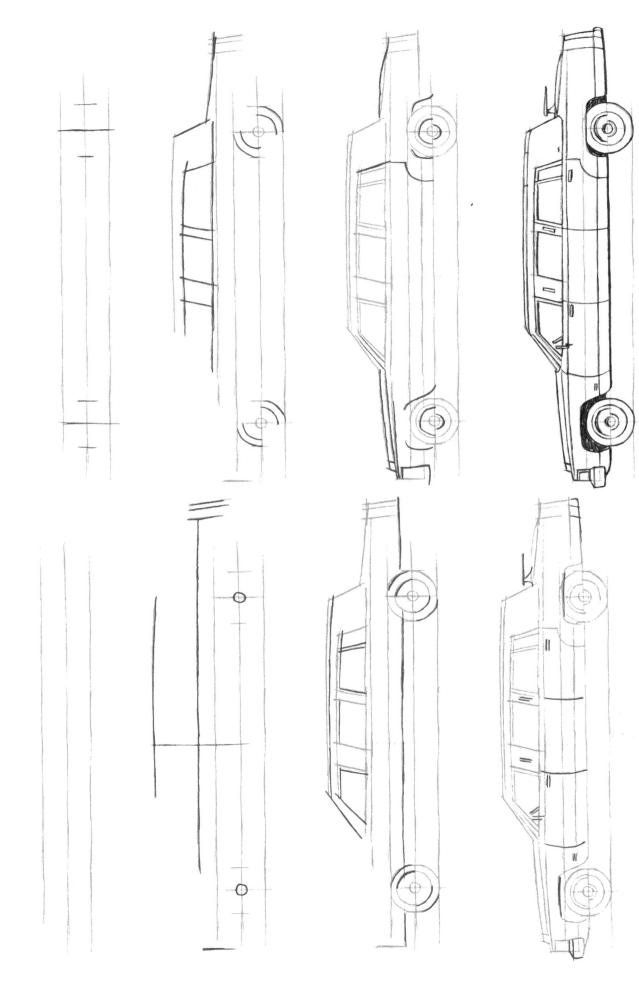

1981 Cadillac Limousine

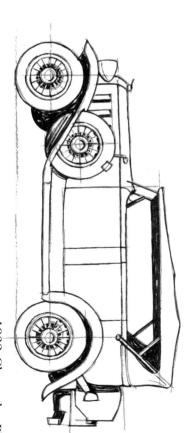

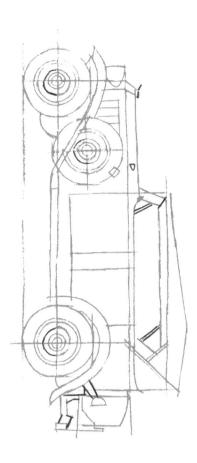

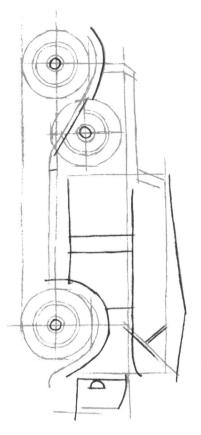

Ø

2

日 日

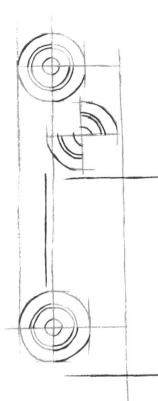

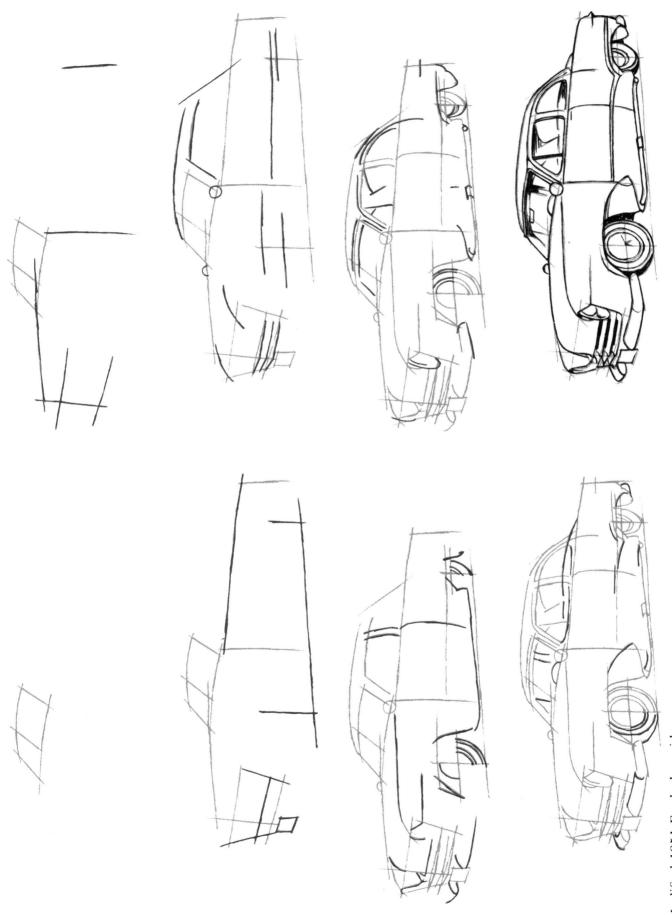

Modified 1951 Ford-low rider

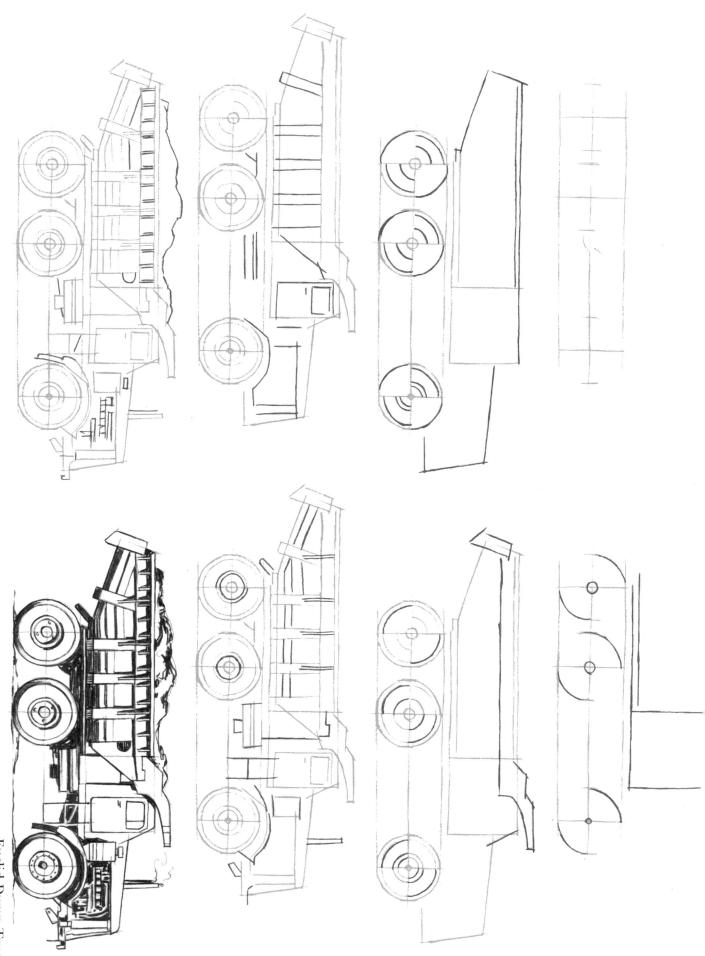

Euclid Dump Truck

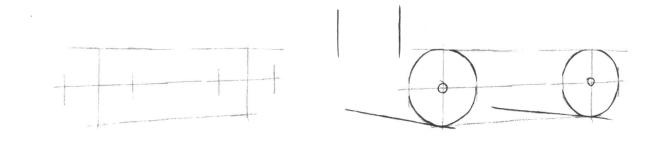

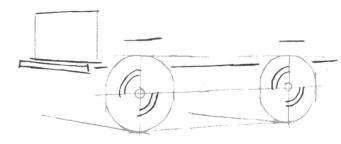

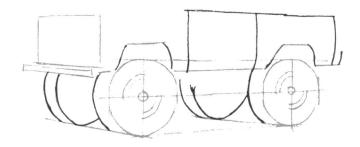

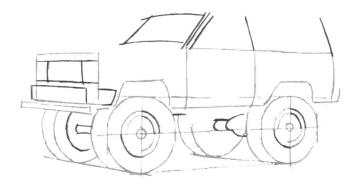

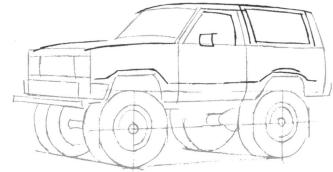

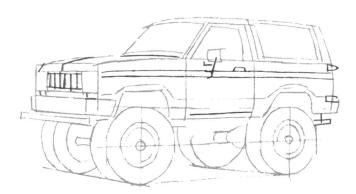

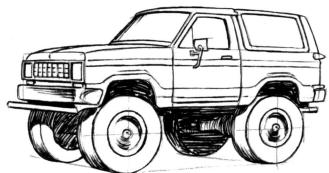

Ford Bronco II

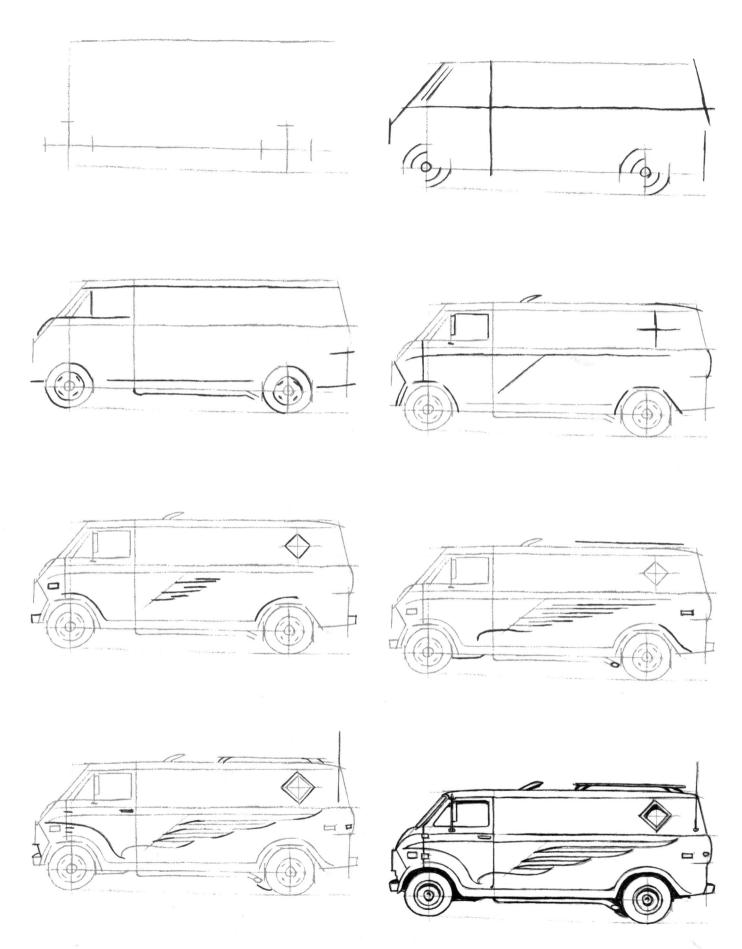

1974 Ford E-100 Custom Van

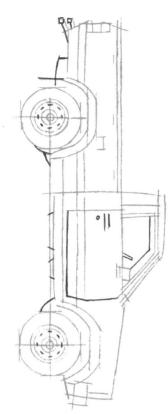

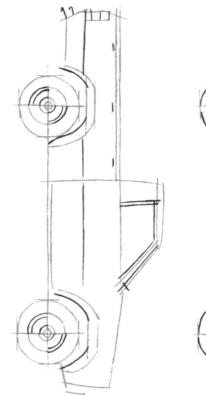

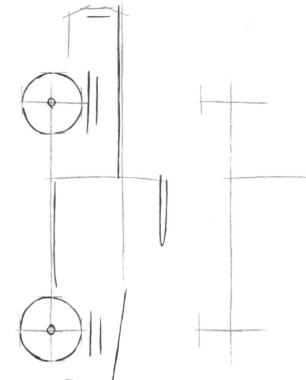

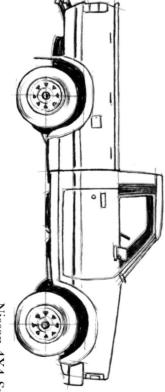

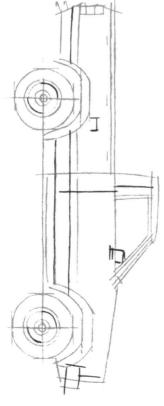

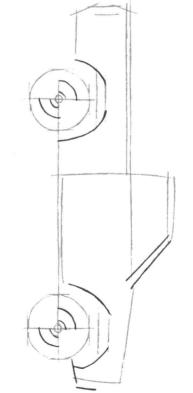

Nissan 4X4 Sport Truck

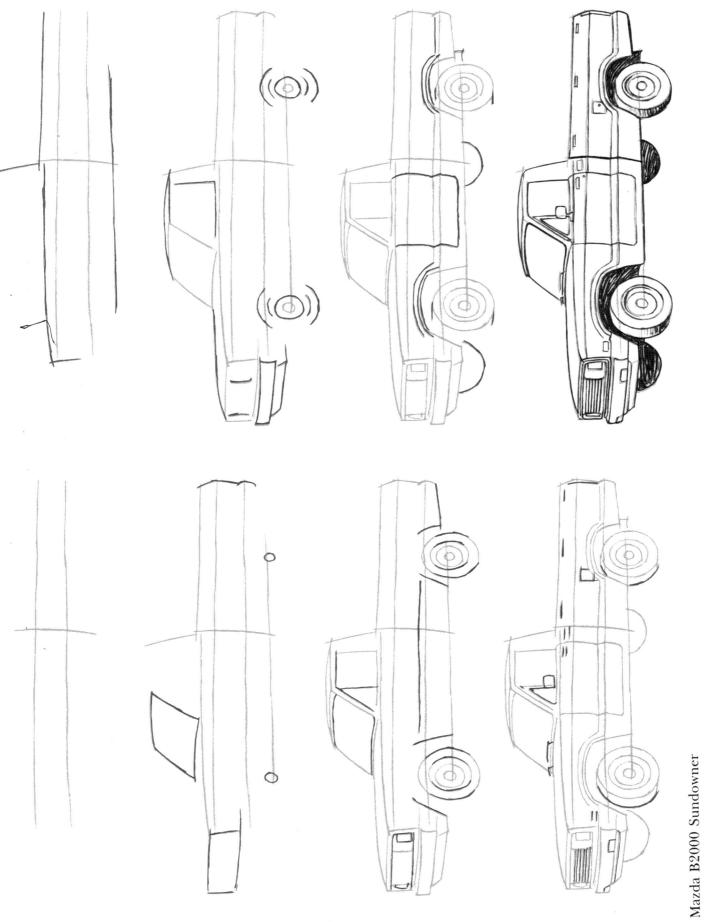

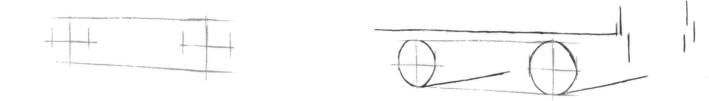

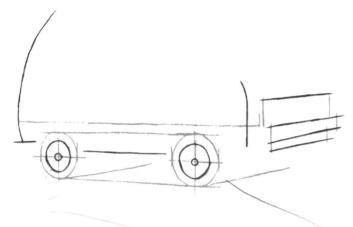

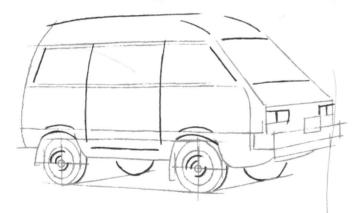

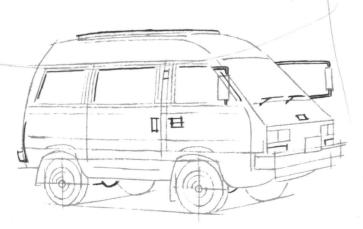

Micro Van-Subaru's Domingo

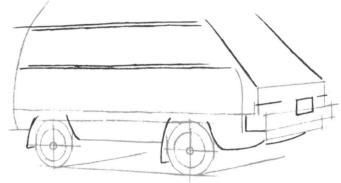

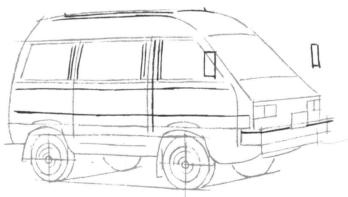

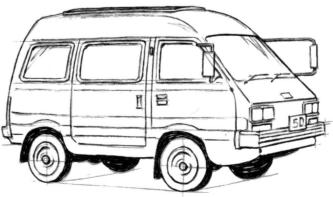

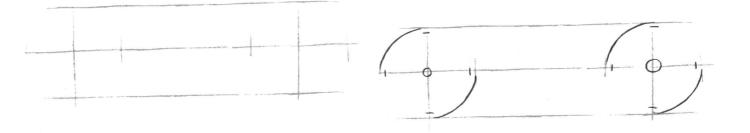

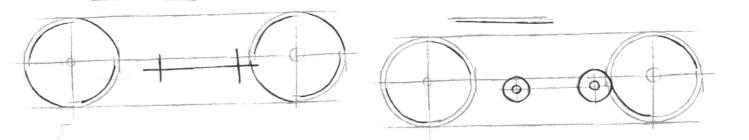

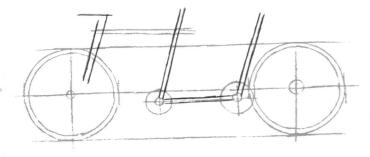

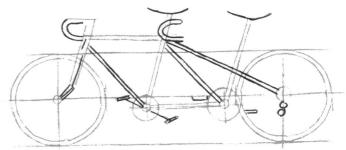

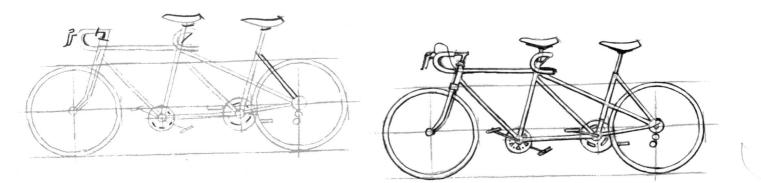

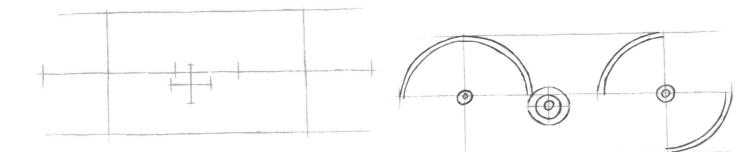

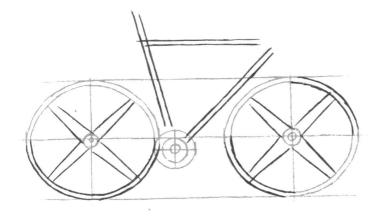

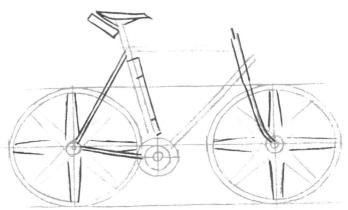

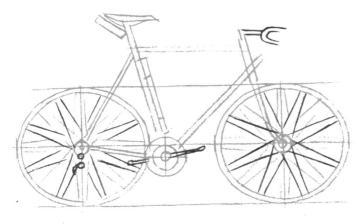

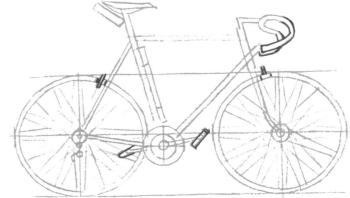

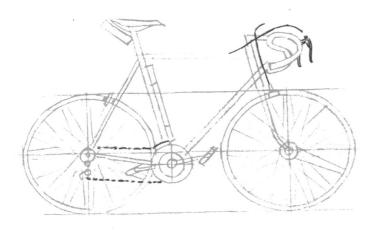

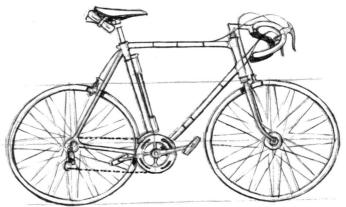

Road Racing Superbike

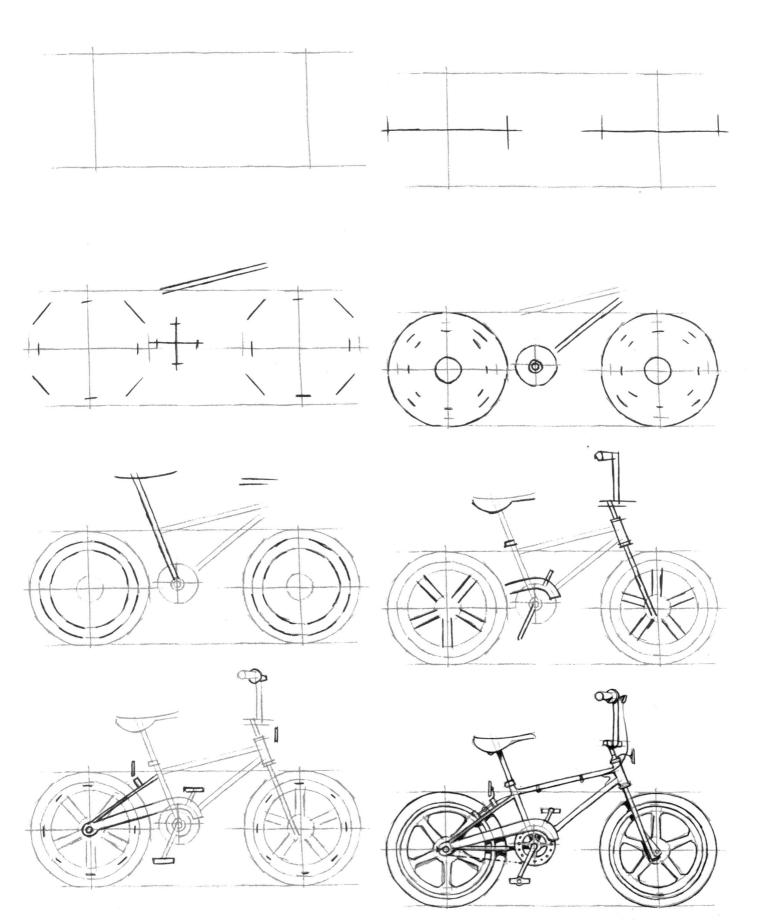

Motocross (Panasonic) with Piranha wheels

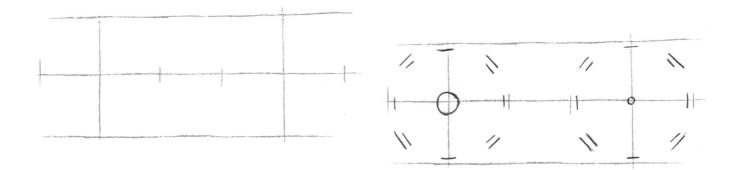

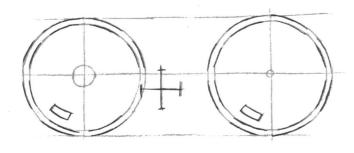

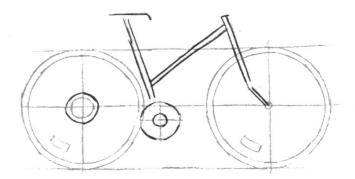

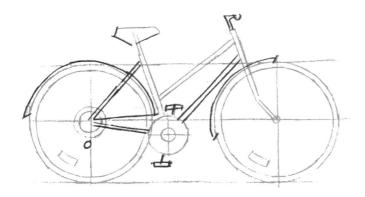

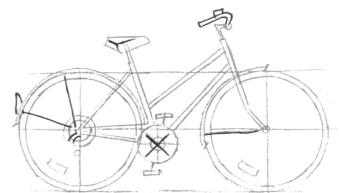

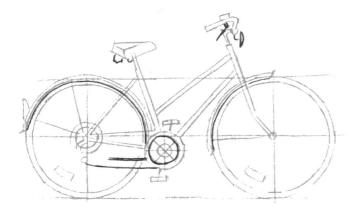

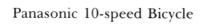

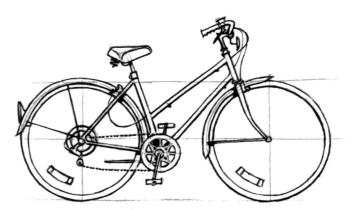

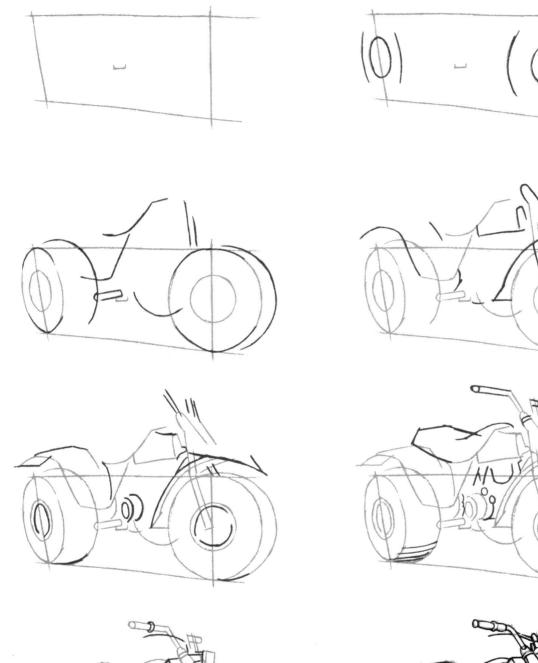

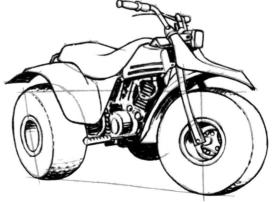

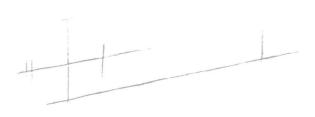

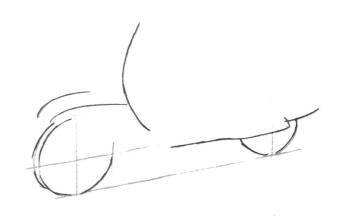

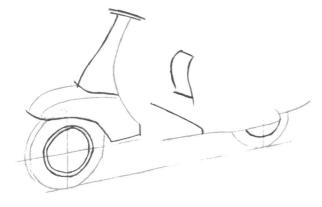

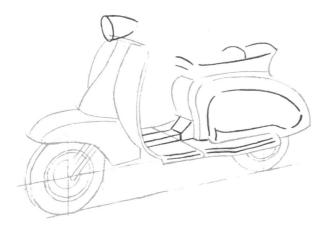

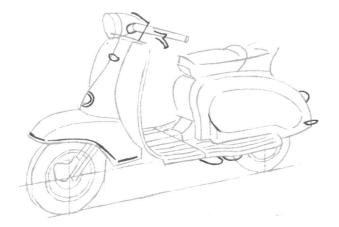

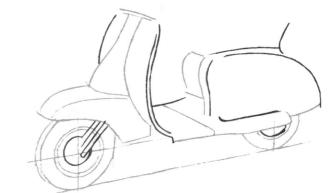

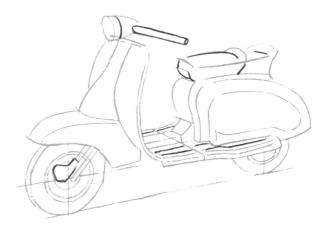

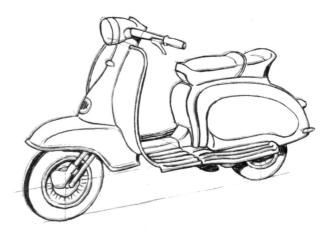

Lambretta Scooter T-V175

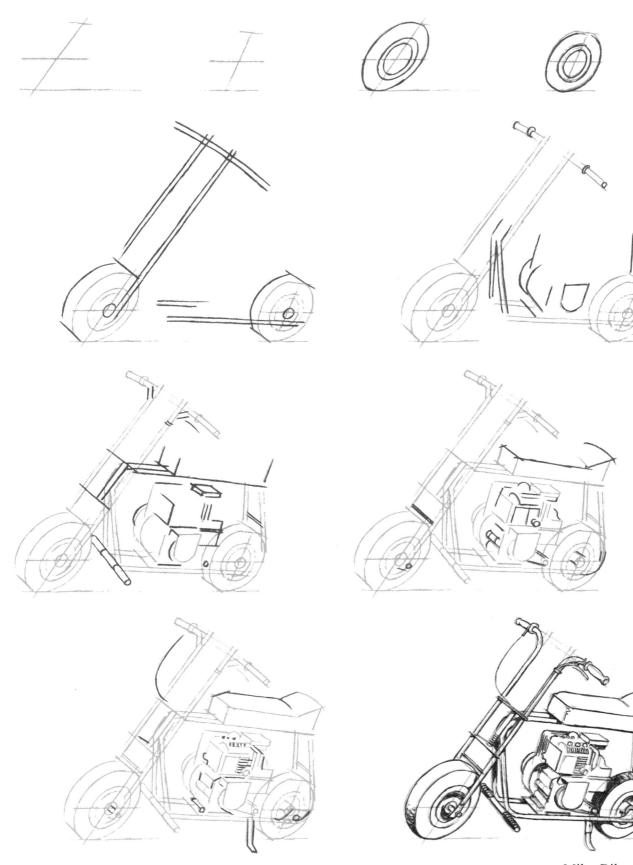

Mike-Bike MB-6L

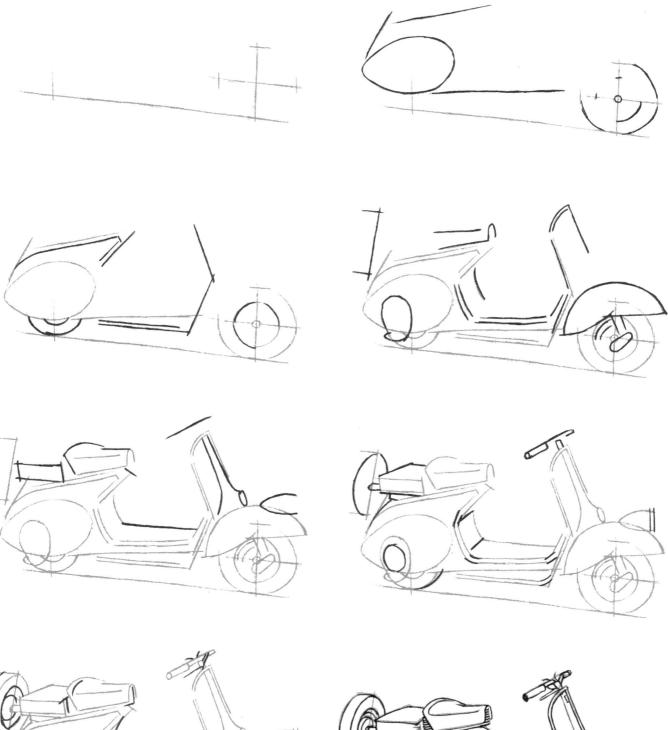

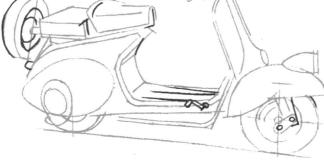

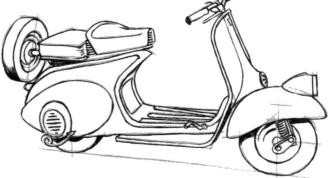

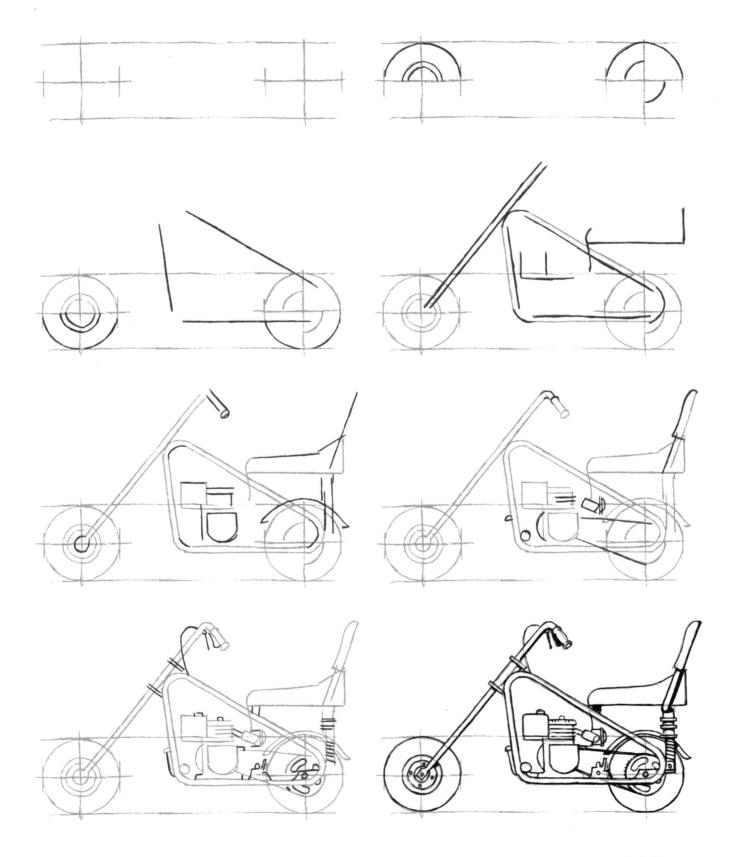

Mini Chopper

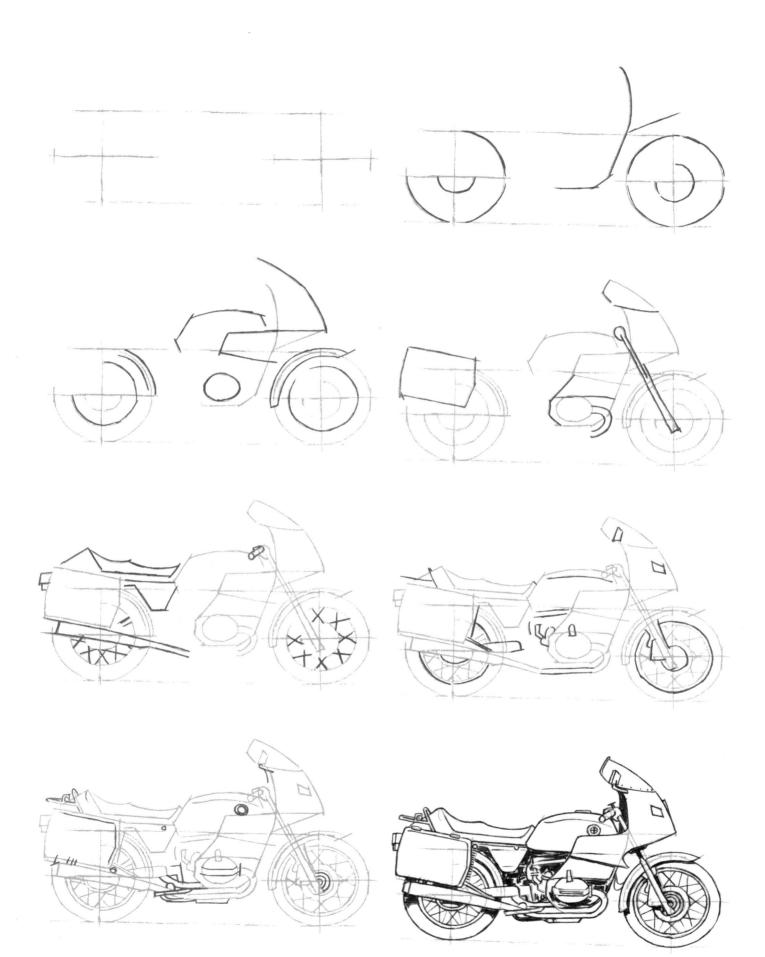

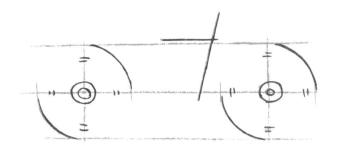

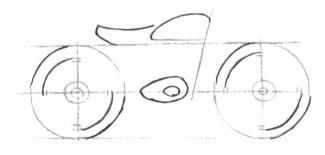

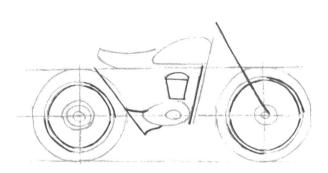

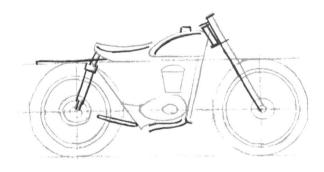

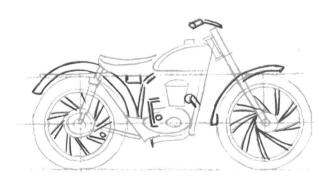

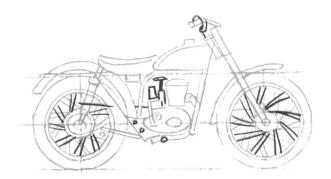

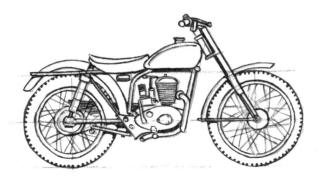

Francis-Barnett 249-c.c. Scrambler

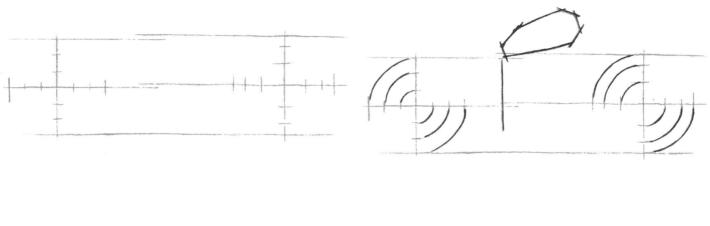

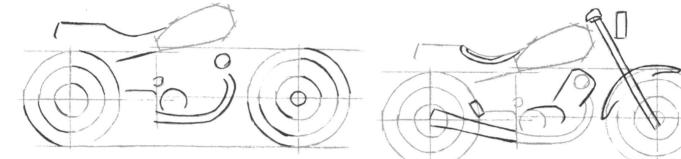

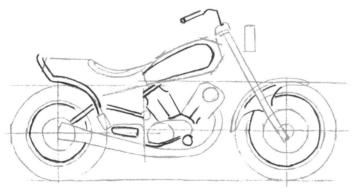

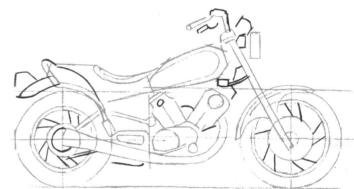

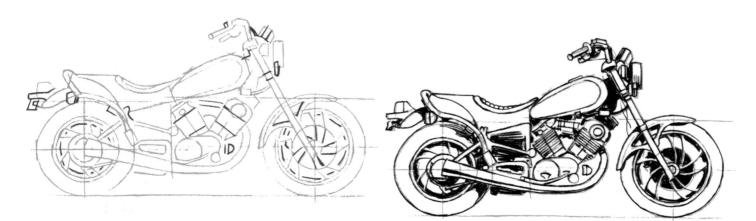

Yamaha Virago

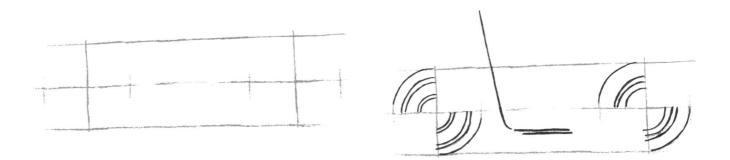

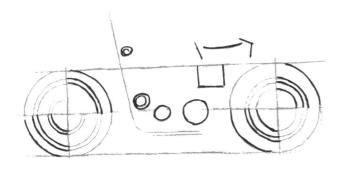

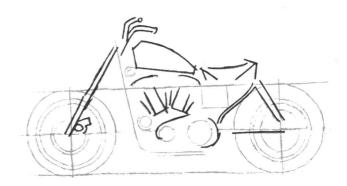

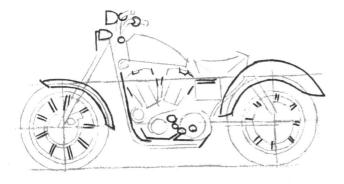

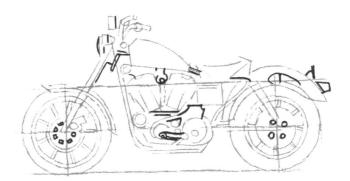

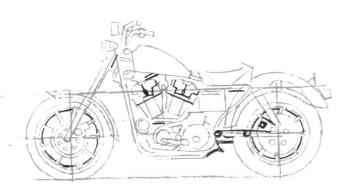

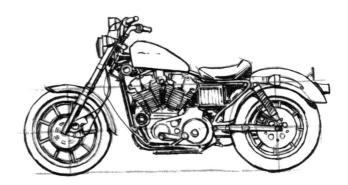

Harley-Davidson XLH 883 Sportster

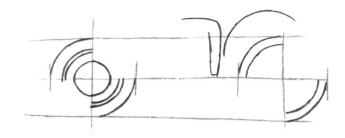

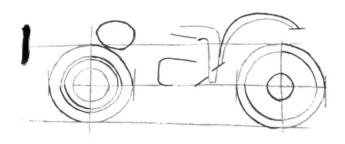

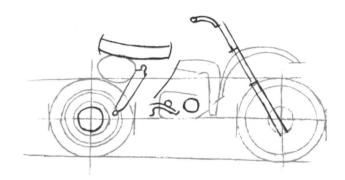

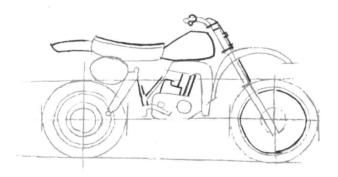

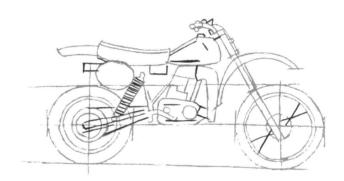

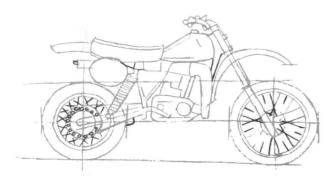

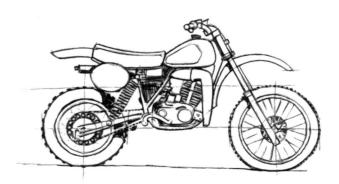

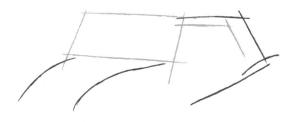

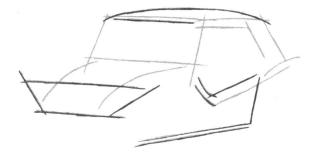

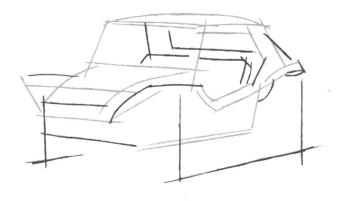

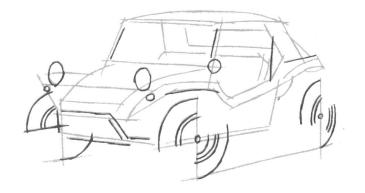

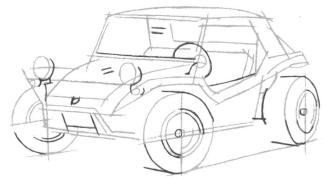

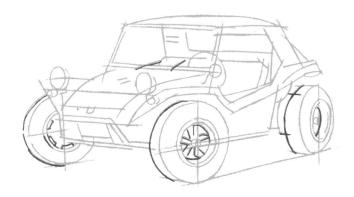

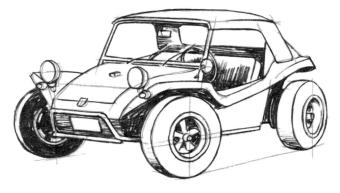

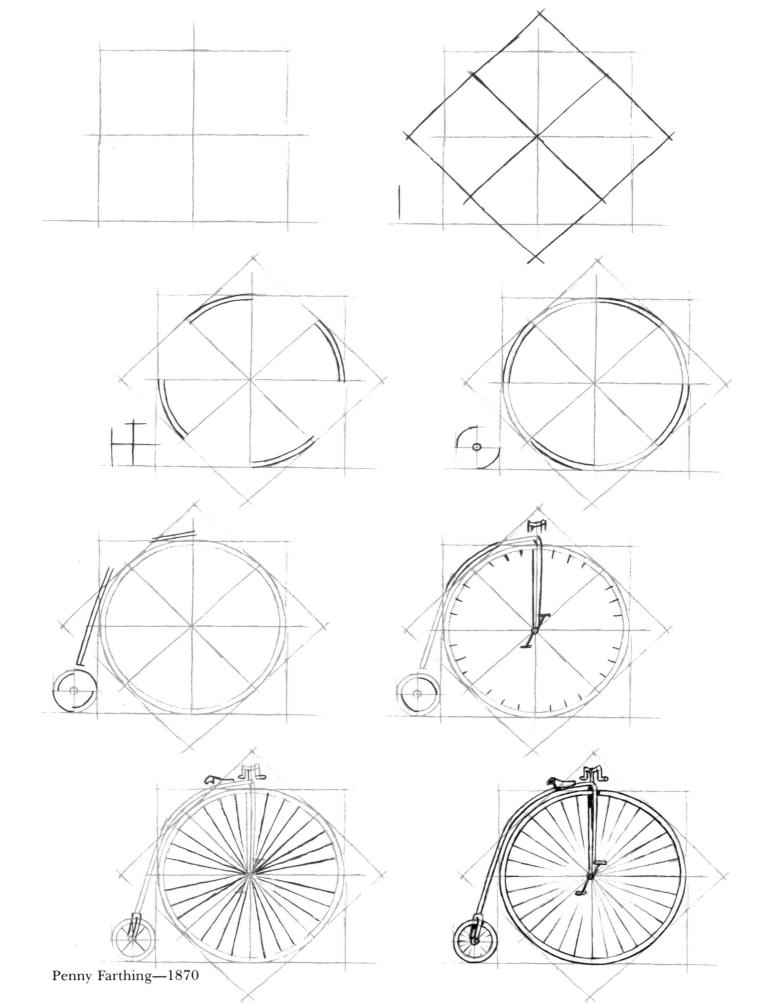

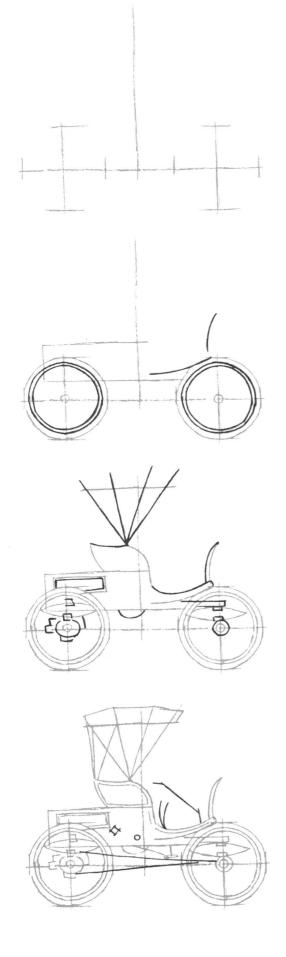

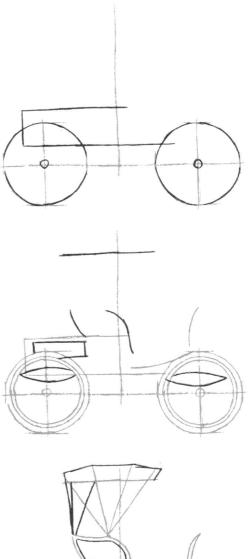

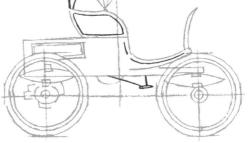

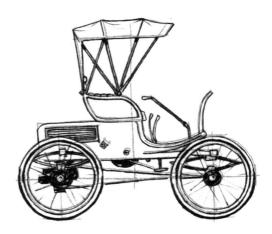

1898 Winton Buggy

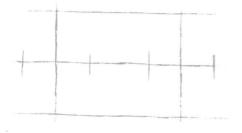

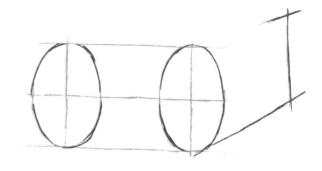

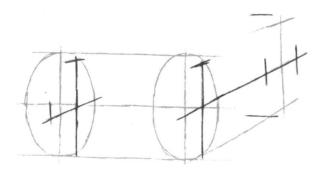

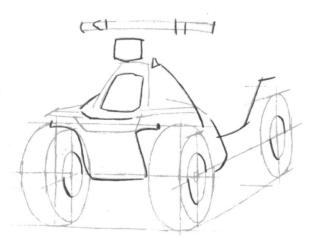

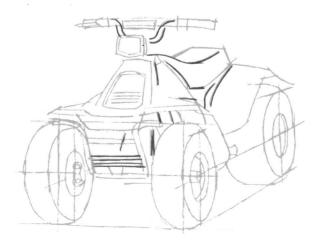

Suzuki Quadrunner 125

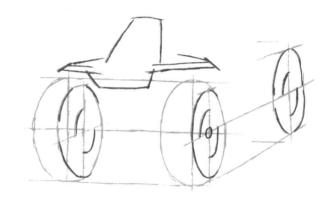

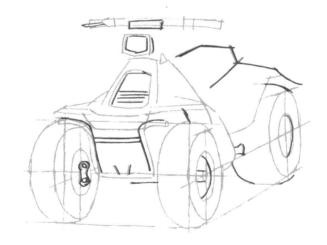

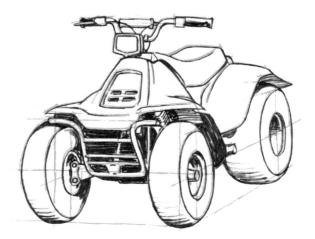

Lee J. Ames began his career at the Walt Disney Studios, working on films that included *Fantasia* and *Pinocchio*. He taught at the School of Visual Arts in Manhattan, and at Dowling College on Long Island, New York. An avid worker, Ames directed his own advertising agency, illustrated for several magazines, and illustrated approximately 150 books that range from picture books to postgraduate texts. He resided in Dix Hills, Long Island, with his wife, Jocelyn, until his death in June 2011.

UNION COUNTY PUBLIC LIBRARY 316 E. Windsor St., Monroe, NC 28112

DRAW 50 CARS, TRUCKS, AND MOTORCYCLES

Experience All That the Draw 50 Series Has to Offer!

With this proven, step-by-step method, Lee J. Ames has taught millions how to draw everything from amphibians to automobiles. Now it's your turn! Pick up the pencil, get out some paper, and learn how to draw everything under the sun with the Draw 50 series.

Also Available:

- Draw 50 Airplanes, Aircraft, and Spacecraft
- Draw 50 Animals
- Draw 50 Athletes
- Draw 50 Baby Animals
- Draw 50 Flowers, Trees, and Other Plants
- Draw 50 Sharks, Whales, and Other Sea Creatures
- Draw 50 Vehicles